XIU XIU

THE POLAROID PROJECT

XIU XIU: THE POLAROID PROJECT: THE BOOK
© 2007 BY DAVID HORVITZ

ALL PHOTOGRAPHS © DAVID HORVITZ & XIU XIU

DESIGN: CHRISTOPHER D SALYERS
PRODUCTION ASSISTANT: ELIANE LAZZARIS
EDITING: BUZZ POOLE

TYPEFACES USED: CORDOBA & DEAR SARAH

LIBRARY OF CONGRESS CONTROL Nº 2007930509

PRINTED AND BOUND IN CHINA THROUGH ASIA PACIFIC OFFSET

10 9 8 7 6 5 4 3 2 1 FIRST EDITION

THIS EDITION © 2007
MARK BATTY PUBLISHER
36 WEST 37TH STREET, PENTHOUSE
NEW YORK, NY 10018

ISBN-10: 0-9790486-5-6
ISBN-13: 978-09790486-5-4

DISTRIBUTED OUTSIDE NORTH AMERICA BY:
THAMES & HUDSON LTD
181A HIGH HOLBORN
LONDON WC1V 7QX
UNITED KINGDOM
TEL: 00 44 20 7845 5000
FAX: 00 44 20 7845 5055
WWW.THAMESHUDSON.CO.UK

WWW.MARKBATTYPUBLISHER.COM
WWW.DAVIDHORVITZ.COM
WWW.XIUXIU.ORG

XIU XIU

THE POLAROID PROJECT

the book

MARK BATTY PUBLISHER
NEW YORK CITY

MANY THANK YOU'S TO:

UTA BARTH

JHEREK BISCHOFF

BRENDAN FOWLER & ANP QUARTERLY

MYLINH TRIEU NGUYEN

MIYA OSAKI

MARY PEARSON

BY
DAVID HORVITZ

I FIRST MET XIU XIU THROUGH FREDDY RUPPERT ON A TOUR ACROSS CANADA IN 2005. SINCE THEN I HAVE BEEN TRAVELING WITH THE BAND THROUGHOUT NORTH AMERICA. ON THE PAST THREE TOURS, UNDER THE TITLE, THE XIU XIU POLAROID PROJECTS, I OFFERED ANYONE ATTENDING THE SHOWS THE OPPORTUNITY TO HAVE POLAROIDS SHOT DURING THE CURRENT TOUR MAILED TO THEM. FOR NO EXTRA COST, IF THEY BROUGHT A BOX OF POLAROID FILM AND AN ENVELOPE WITH STAMPS TO THE SHOWS, I TOOK THE PHOTOGRAPHS, SEALED THEM IN THEIR ENVELOPES, AND DROPPED THEM IN A MAILBOX. AS OF NOW THERE HAVE BEEN THREE COMPLETED PROJECTS WITH A ROUGH ESTIMATE OF AROUND 1,800 POLAROIDS. THESE EXIST AS A LARGE BODY OF IMAGES SCATTERED AROUND NORTH AMERICA IN THE HANDS OF DIFFERENT PEOPLE. THE FOLLOWING IMAGES ARE FROM THIS COLLECTION, EACH EXISTS SOMEWHERE IN THE WORLD.

WORDS BY JAMIE STEWART

CAR CRASH

HUMILIATION WHEN YOU PLAY BADLY

DRUNKENNESS

LOW-GRADE FEVER

SORE THROAT

THROBBING WRIST

MANGLED KNUCKLES

BLACK ICE

SIMMERING HATE

BORING REPETITIVE CONVERSATIONS

WAFFLE HOUSE

ANT BITES

THEFT

YELLING AT TEENAGERS

GUITAR CENTER

LOST PURSE

GETTING LOST

FORGETTING PEOPLE'S NAMES

WONDERING IF YOU HAVE LOST

BEING ON THE ROAD FOR TOO LONG DAY AFTER DAY, COUPLED WITH NIGHTLY SHOWS, WE GET EATEN BY TOUR-CRAZY.

FIRST OF ALL, YOU START TO THINK ABOUT TOO MANY THINGS DURING THE LEGION HOURS SPENT IN A MOVING VEHICLE — SO MUCH THAT YOUR MIND BECOMES A STRANGER TO YOURSELF. PARADOXICALLY, SUCH ESTRANGEMENT CREATES NOT DISTANCE, BUT INTIMACY, OR PERHAPS MORE ACCURATELY, OBSESSION; YOU BECOME OBSESSED WITH YOUR OWN MULTIFARIOUS AGGLOMERATION OF THOUGHTS, IDEAS, ASSOCIATIONS AND EMOTIONS. YOU BECOME ABSORBED IN THE GROWING UNFAMILIARITY OF THE SELF.

AS WE START CHEWING AROUND IN OUR MOUTHS THE PIECES OF THE USUAL CONFLICTS AND EXCITEMENTS THAT ARE MEANINGFUL ONLY IN RELATION TO RESTRICTIVE AND LOCALIZED ATTACHMENTS, WE REALIZE THEY ARE STARTING TO LOSE THEIR FLAVORS. OUR DISAFFECTION POPS AND SNAPS FROM BETWEEN OUR TEETH LIKE OLD GUM, AND WE FIND OURSELVES NO LONGER OVERWROUGHT BY SOME SUCH HABITUATED THINGS THAT WERE ONCE SO MONUMENTAL AND IRRECONCILABLE BEFORE, AT LEAST NOT IN THE SAME MANNER. SOMETIMES THEREAFTER IS AN AGGRAVATING SENSE OF DISILLUSIONMENT, SOMETIMES, MERELY UNCONTESTABLE CLARITY. I GUESS IT'S ALL WHAT YOU MAKE OF IT.

THE CONSTANT MOTION FROM ONE CITY TO ANOTHER CHALLENGES THE CONCEPT OF THE FAMILIAR AND FOREIGN, WHAT IS RELATABLE AND COMPLETELY UNRECOGNIZABLE. IN EVERY PLACE IT SEEMS YOU FIND SOME OF BOTH. BUT MOST OF ALL, THE UNFAMILIAR GROWS FROM WITHIN. NORMAL EXPRESSIONS OF EXHAUSTION, EXCITEMENT, ANXIETY, ALL EMOTIONS, CEASE TO BE ADEQUATE AND OUR KNOWN ATTRIBUTES SEEM TO BECOME A LITTLE DISTORTED. WE ADAPT A SLIGHTLY FOREIGN, YET DEFINITELY RECOGNIZABLE, BEHAVIOR AND RHETORIC AS THE ID REARS ITS GRUESOMELY ATTRACTIVE HEAD.

AT A GAS STATION, AS A POLITE MIDWEST GRANDMA WAS RINGING ME UP, DAVID LEANS AGAINST ME AND ALMOST SHOUTS, "HELLO, BIG DICK!" OUR MAD LIB GAMES START BECOMING RIDICULOUS, MORE REMINISCENT OF A MARQUIS DE SADE TALE THAN CHILD'S PLAY. [BUT PERHAPS THE TWO ARE NOT SO DIFFERENT.] WE THINK WE ARE ALL GOING TOTALLY NUTS. EVERYTHING IS FUNNY BUT NOTHING IS FUN.

THE CONSTANTLY LOUD INSISTENCE OF DAVID'S CAMERA ADDS YET ANOTHER LAYER OF
CONSCIOUSNESS. OUR ALREADY MORPHED ACTIONS BECOME SUBTLY TINGED WITH
PERFORMANCE, WITH A TRUE SENSE OF HALF-CONSCIOUS EXHIBITIONISM. WE CREATE
AND PERFORM IN A DE-TERRITORIALIZED ZONE OF THE PRIVATE AND THE PUBLIC. WELL,
THIS IS ALWAYS TRUE WHEN CREATING AND PERFORMING, YET DAVID'S CAMERA TRAMPLES
AND EXTENDS THIS ZONE INTO OTHERWISE NORMALLY PRIVATE SPACES OF OUR CHEAP
MOTEL ROOMS, BATHS, CARS, BACKROOMS, AND EVEN TOILETS.

THERE EXISTS IN CYCLES THE RAPACITY FOR EXTREMES, TO TAKE THINGS OVER THE
TOP OVER AND OVER AGAIN, MOSTLY BECAUSE YOU CAN, AND IT DOESN'T MATTER – THE
OBSESSION AND DISAFFECTION, MATCHED WITH THE LUST FOR THE HYENA-LAUGHS OF
THE UNCOMFORTABLE, THE RECEPTIVE SILENCE OF THE UNFAMILIAR, AND THE RELIEF
OF THE ABSURD. IN SUCH A STATE OF TRANSIENCE IS A SENSE OF SOMETHING CONTINU-
ALLY CRAVED AND NOT REALIZED. WHETHER THIS CRAVING AND CONFUSION IS CONTAINED
WITHIN THE METAL WALLS OF OUR OWN VAN, OR DERIVED AND IN TURN SPREAD ALONG
THE LONG STRETCHES OF ROAD WE WHEEL THROUGH, I'M NOT SURE. I WOULD LIKE TO
THINK THE LATTER. WE ARE LIKE MISSIONARIES TRYING TO CONVERT OUR OWN PAGAN
UNHAPPINESS INTO THE TRUE FILTH OF MUTUAL FAITH AND FULFILLMENT.

DO THIS FOR ME.

WORDS BY **CARALEE McELROY**

WHEN I WAS A LITTLE GIRL I WAS A HAM. I'D PUSH MY WAY INTO THE FRONT OF PHOTOS, OR IF I COULDN'T DO THAT I WOULD MAKE FACES SO THAT I WOULD STAND OUT IN THE FRAME. YOU COULD SAY I WAS A PERFORMER FROM AN EARLY AGE. LIP-SYNCING BEATLES SONGS IN FRONT OF MY FAMILY WHILE HOOLA-HOOPING WAS A REGULAR NIGHT IN MY HOUSEHOLD.

WHEN THE TIME CAME THAT I WOULD BE IN XIU XIU I HAD TO LEARN TO HOLD BACK. WHEN XIU XIU PERFORMS I FEEL THE NEED TO DO THE BEST I CAN MAKING THE MUSIC HAPPEN, NOT BE A GOOF BALL. I MADE THE DECISION THAT I WOULD NOT PUSH MYSELF TO THE FRONT, LEAVING A SHADOW ON THE MUSIC.

AFTER SHOWS PEOPLE OFTEN COME UP TO ME AND ASK IF I WAS UPSET DURING THE SHOW. THEY THINK THAT I LOOK SO SERIOUS WHEN I PERFORM AND ARE RELIEVED TO FIND OUT THAT I'M ACTUALLY A PRETTY FRIENDLY SMILEY PERSON. I THINK THAT TOURING, THOUGH IT HAS MANY, MANY PERKS, IS AN INCREDIBLY EXHAUSTING AND EMOTIONALLY DRAINING EXPERIENCE. IT'S EASY, ESPECIALLY WITH THE MUSIC WE PLAY, TO GET DOWN A BIT.

WHEN DAVID INTRODUCED THE IDEA OF THE POLAROID PROJECT I COULDN'T WAIT TO GET IN FRONT OF THAT CAMERA AND DORK OUT. IT REMINDS ME THAT THERE ARE SOME MOMENTS ON TOUR THAT ARE LIGHT-HEARTED. I LOVE THAT WE COULD SHARE THESE MOMENTS WITH OUR FANS, SO THEY COULD SEE ALL THE DIFFERENT SIDES OF XIU XIU, WHILE HAVING FUN IN THE PROCESS.

A PERSPECTIVE ON CHES SMITH

MOST OF THE PHOTOGRAPHS IN THIS BOOK ARE OF THE MOMENTS THAT YAWN
BETWEEN SHOWS, OR BLUR LIKE A HEAD RUSH, OR STUMBLE, GAMBOL, OR DRAG:
THE SKIES, MOTEL ROOMS, THE ULTRAMARINE POLYMER BOOTHS WHERE BANDS
EAT FOODSTUFFS WITH CHEESE THAT COOLS INTO THE SAME PLASTIC SHEEN. AND
FOR ALL OF THESE REASONS, IT IS APPROPRIATE THAT DRUMMER CHES SMITH IS
THE ONLY BAND MEMBER TO BE CAPTURED HERE ON STAGE, SOUND-CHECKING A
VIBRAPHONE. FOR SMITH, THERE IS NO DIVISION BETWEEN BEING ONSTAGE AND
OFF. "I'M THE MOST SANE WHEN I LET EACH MOMENT JUST HAPPEN," HE SAYS.
"IT'S WHY I DON'T EVEN BOTHER TO WARM UP ANY MORE."

FRIENDS WITH JAMIE STEWART FROM BEFORE THERE WAS A XIU XIU, SMITH
STEPPED INTO THE MIDDLE OF DAVID HORVITZ'S POLAROID PROJECT BY VIRTUE OF
GOING ON THE ROAD WITH THE BAND. "AT FIRST I WAS INDIFFERENT. NO, I WAS
ANNOYED, BUT THEN I REALIZED THAT DAVID IS HILARIOUS, AND I TRUSTED HIM.
HE WASN'T GOING TO MAKE ME LOOK ANY WORSE THAN I MAKE MYSELF LOOK."

AND HERE IS THE MAGIC OF THESE IMAGES, THEIR SINCERITY TO BE NOTHING MORE
THAN THEY ARE. THEY ARE NOT ROMANTIC, OR GLORIFIED, OR SEXY, OR ENVIABLE,
NO MATTER HOW MUCH YOU LIKE THE IDEA OF GETTING WASTED AND GETTING INTO
HOTEL HIJINKS. BECAUSE THESE ARE NOT WHY ANY OF THESE MUSICIANS ARE ON
THE ROAD, AND IT IS CERTAINLY NOT WHY HORVITZ TRAVELS WITH THEM, PUSH-
ING MERCH AND ACCEPTING POLAROID FILM FROM ANYONE THAT GIVES IT TO HIM.
DEVOTION TO A GREATER GOOD, TO A MOMENT WHERE PLACE AND THE INDIVIDUAL
WED, AND THEN DIVORCE IMMEDIATELY, THOUGH THE OFFSPRING CAN BE FELT, IN
THE CASE OF THE MUSIC, HEARD; IN THE CASE OF THESE PHOTOGRAPHS, SEEN AND
HELD, THAT IS THE PURPOSE.

CHES SMILES AS HE LEANS AGAINST A RESTAURANT-BOOTH WALL, BOTTLES OF
HEINEKEN ON THE TABLE; IS CAUGHT BEHIND A PAIR OF SHADES IN A MOTEL ROOM
INTO WHICH THE SUN HAS NOT SHOWN IN HOURS; STARES OUT INTO THE CHOPPY
SEA. ALL OF IT, THE SAME AS WHEN HE GETS BEHIND HIS KIT, PRIVILEGES THE
MOMENT, FOR IT IS ALL WE CAN EVER HAVE.

ONCE GONE – THE MOMENT, ANY MOMENT, THAT MOMENT – IT BECOMES SOMETHING
ELSE, A MEMORY, OR A SONG OR ART. IT IS SHARED. AND WHILE CERTAIN OF THESE
TOKENS OFFERED UP IN THIS BOOK HAVE BEEN SPURRED, THEY ARE NOT FALSE.
"IT'S FUNNY," CHES GOES ON, "IT EITHER INHIBITS US OR WE GO WAY CRAZIER,
BUT IT'S US."

AND IT IS THIS COLLECTIVE US – THEM, YOU, ME AND OTHERS – THAT PASS UNDER
THESE SKIES AND SWIM IN THESE SEAS, EAT THE FOOD AND HEAR THE MUSIC.
NONE OF IT IS RECEIVED THE SAME, THOUGH IT ALL COMES FROM THE SAME
SOURCE: THE MOMENT.

words by Buzz Poole

A SMALL COLLECTION OF LOOKING

(AT MOMENTS OF DISTRACTION OR FRAGMENTS OF A WORLD):

SOME SKIES – BLUE OR GREY – A STREETLIGHT TURNING ON AT DUSK, A BILLBOARD IN
THE DESERT, A TREE SHADOW ON THE SIDEWALK, A VIEW OF THE HORIZON EAST IN THE
ATLANTIC OR WEST IN THE PACIFIC, A PIER IN CONEY ISLAND, THE FOG IN SANTA MONICA,
A SMALL PORT-TOWN IN NORTH CAROLINA, A PATH INTO CAPE COD TREES, PALOS VERDES.

IF THE TOUR STARTED ON THE WEST COAST AND NOT IN SALT LAKE CITY, THERE WOULD
HAVE BEEN POLAROIDS OF WENDOVER, A SMALL TOWN THAT BORDERS NEVADA AND
UTAH. HERE, OVER HALF A CENTURY AGO, THE U.S. MILITARY BUILT THE ENOLA GAY AND
FLEW TEST RUNS FOR THE ATOMIC BOMB DROPPINGS ON HIROSHIMA AND NAGASAKI.
ABANDONED: OLD WEATHERED BARRACKS, AN AIRPLANE HANGAR. WOULD ANYONE KNOW
THE FERTILE HISTORY OF A POLAROID OF A BARREN LANDSCAPE?

OR LOOKING UP AT THE SKY IN THE MIDDLE OF THE NIGHT AT A GAS STATION SOMEWHERE
A FEW MILES PAST SAND CREEK. THE STARS LOOK SO BEAUTIFUL HERE; THEY CAN
ENTHRALL YOU, EVEN IN THE COLD. BUT IF I POINTED THE CAMERA UP ALL THERE WOULD
BE IS BLACK. THEY WOULD NEVER MAKE IT ONTO THE EMULSION.

NOW I AM ON A PLANE FROM NEW YORK TO REYKJAVIK. THE WINDOW FACES SOUTH OVER
THE ATLANTIC. IT IS DAWN AND THE SUN IS ABOUT TO RISE. THE MOON, A WANING
CRESCENT (ALMOST A NEW MOON) IS ALREADY ABOVE THE HORIZON. AT FIRST I DO NOT
REALIZE WHAT IT IS. IT GLIMMERS WITH THE GOLDEN LIGHT OF A SUN THAT HAS NOT YET
RISEN. ALL I CAN COMPREHEND IS THIS LIGHT. SLOWLY I LEARN IT IS THE MOON. THIS
REMINDS ME OF THE LINE IN THAT JOHN BERGER BOOK YOU SHOWED ME. IF I HAD A
CAMERA THAT COULD CAPTURE THIS, THIS VISUAL INCOMPREHENSION – THAT IS THE
PHOTOGRAPH I WOULD MAIL YOU. OR, AT THE LEAST, I WOULD BE SENDING YOU THE MOON.

David Horvitz
May 2007

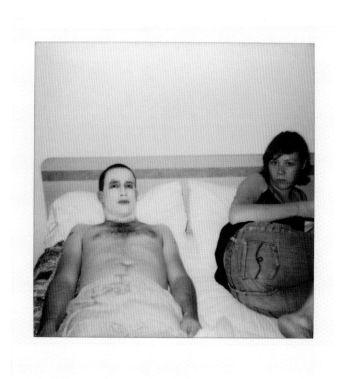

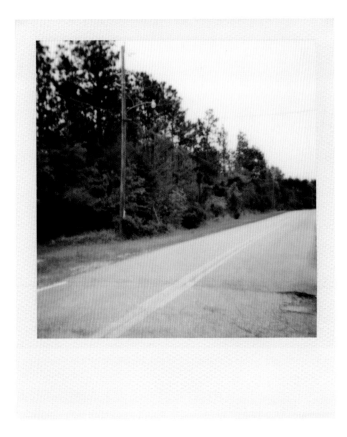

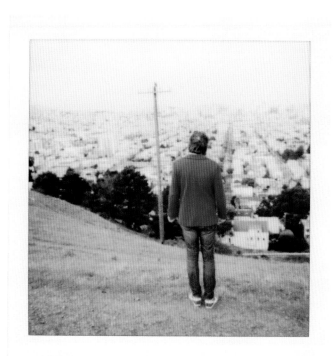

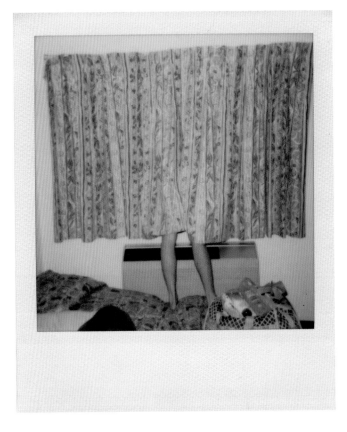

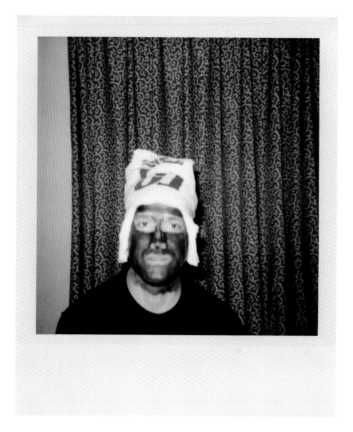

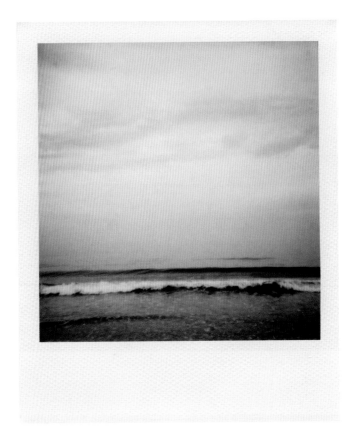

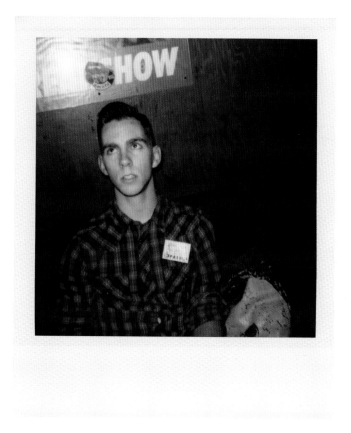

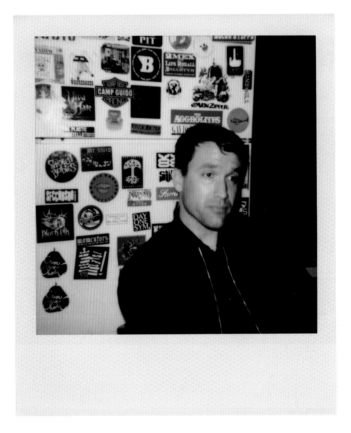

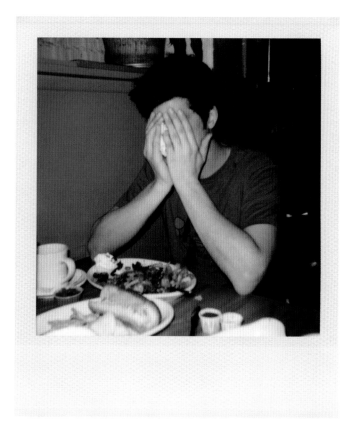

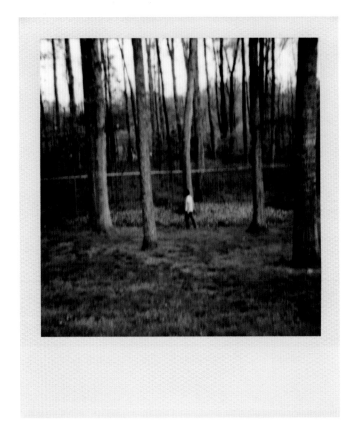

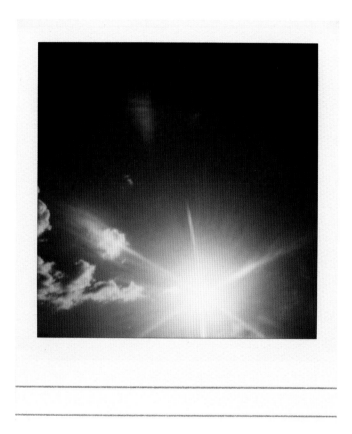

TRAVELING WITH XIU XIU IS A VENTURE INTO ALL THAT IS DEPRESSING, DISTURBING AND INAESTHETIC ABOUT MODERN LIFE; SLEEPING AT MOTEL 6 EVERY NIGHT AND DINING AT EVERY POSSIBLE CRACKER BARREL, WAFFLE HOUSE AND DENNY'S IN NORTH AMERICA.

Mary Pearson, HIGH PLACES

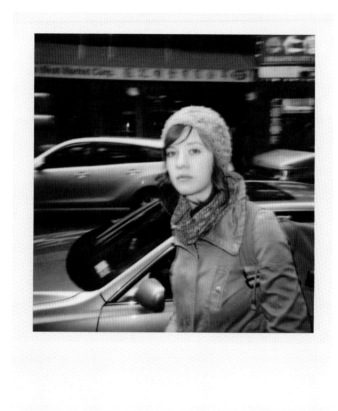

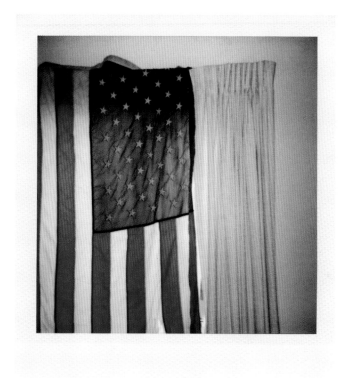

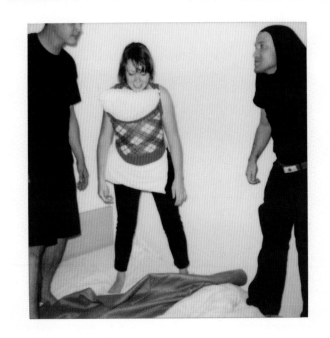

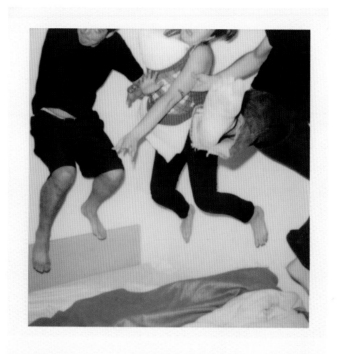

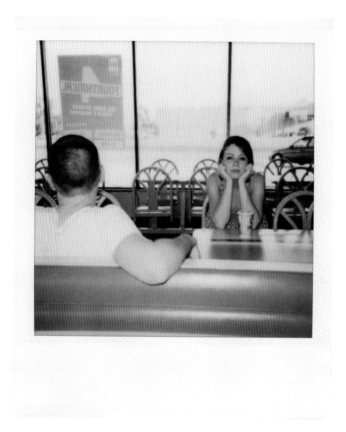

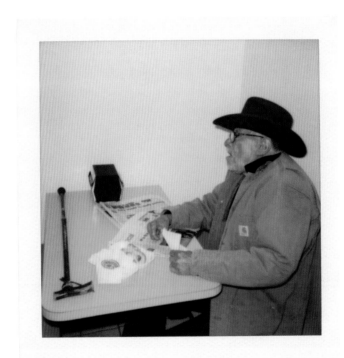

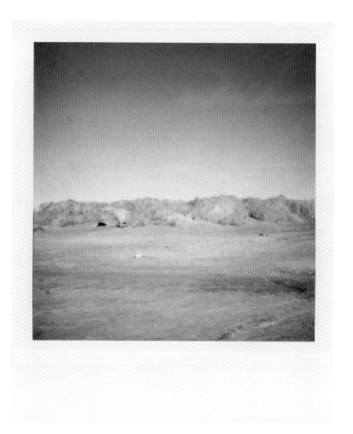

"SO I WAS A HUGE XIU XIU FAN BEFORE, AND GETTING TO TOUR WITH THEM WAS
LIKE A DREAM COME TRUE. I DIDN'T KNOW THEM SUPER WELL, BUT I KNEW DAVID
PRETTY WELL. I FOUND OUT THEY WERE ALL AWESOME PEOPLE, SUPER FUNNY.
BUT I WAS MOST STRUCK BY THEIR FANS. SEEING THEIR FANS EVERY NIGHT ON
TOUR, ESPECIALLY IN SOME NON-METROPOLITAN CITIES, WHERE THEY STILL HAVE
REAL DIE-HARD FAN BASES THAT COME TO SHOWS. THESE XIU XIU FANS ARE ON
A NEAR KIND OF SUICIDAL, QUIET, DEPRESSION SORT OF, LIKE YOU KNOW KIND
OF FREAKING OUT NEED TO BE THERE OR ELSE THEY ARE GOING TO DIE KIND OF
THING. SO, THE WHOLE IDEA OF THE POLAROID THING IS SO... JAMIE IS PRETTY
PRIVATE, ALL THE STUFF DAVID IS DOING WITH THE BLOG, AND THE POLAROID
PROJECT IS SO AMAZING, AND THE IDEA OF GETTING PEOPLE TO GIVE..."
END OF MESSAGE. TO DELETE THIS MESSAGE...

"BUT THE FACT THAT HE'S GOT PEOPLE YOU KNOW GETTING CRAZY ACCESS TO
SUPER INSTANT MOMENTS IS JUST NUTS. LIKE I MEAN THAT PEOPLE ARE
GETTING THINGS THEY COULDN'T REALLY HAVE. YOU KNOW, JAMIE WILL TALK TO
PEOPLE BUT, YOU KNOW CERTAIN OBVIOUS BARRIERS EXIST. YOU ARE NOT GOING
TO SEE THE HOTEL ROOM, LIKE WATCHING JAMIE OR CHES OR CARALEE WITH NO
CLOTHES ON, AND ALL OF A SUDDEN THEY ARE GETTING POLAROIDS OF IT, AND
POLAROIDS ARE LIKE THE ULTIMATE INTIMATE EPITOME OF DOCUMENT IN A WAY.
DAVID IS REALLY INCREDIBLE FOR THINKING TO DO IT. AND PUT SO MUCH ENERGY
INTO IT AND IT'S AMAZING. EVEN QUESTIONABLE. HE'S SENDING SUCH NEAR
NUDITY TO PEOPLE WHO PROBABLY ARE MINORS. I DEFINITELY HAD TO HAVE A
TALK WITH DAVID. I WAS LIKE MAN YOU KNOW I LOVE YOU AND I DON'T WANT TO
CENSOR YOUR ART BUT YOU GOT TO WORRY ABOUT THE LEGAL RAMIFICATIONS IN
SENDING SOME OF THIS STUFF TO CHILDREN. SO, I WOULD LIKE TO THANK EVERY-
ONE INVOLVED, ESPECIALLY DAVID FOR MAKING THIS CRAZY PROJECT.
UHH, BRENDAN FOWLER SIGNING OFF. OVER AND OUT."
END OF MESSAGE.

Brendan Fowler, BARR
[AS TRANSCRIBED FROM TWO VOICEMAIL MESSAGES.]

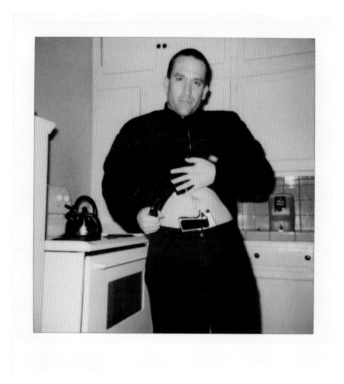

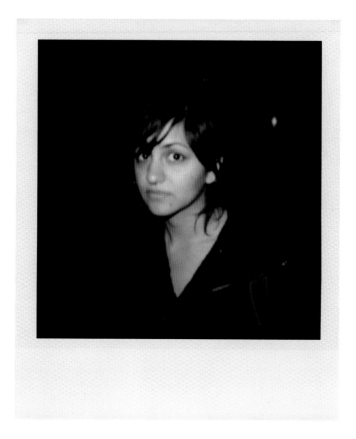

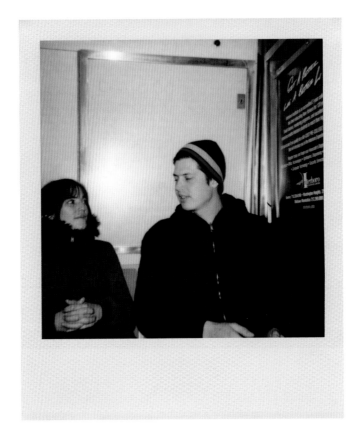

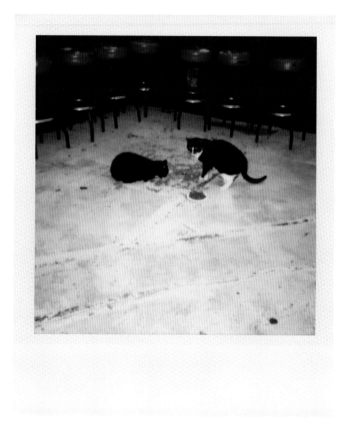

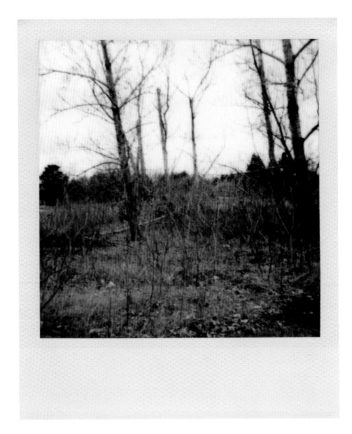

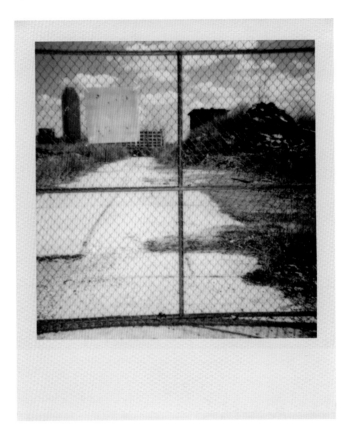

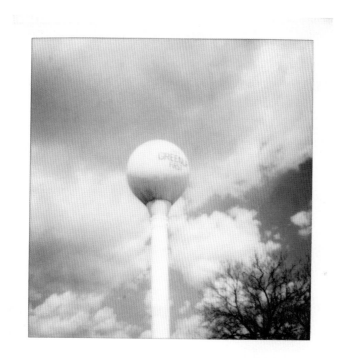

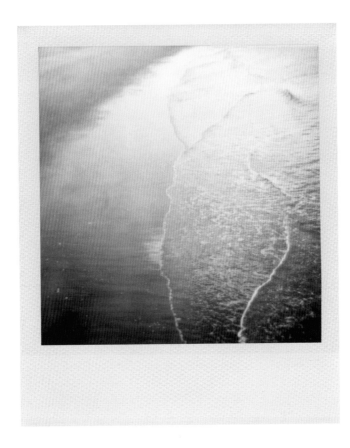

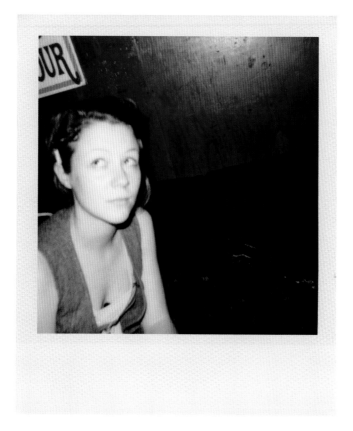

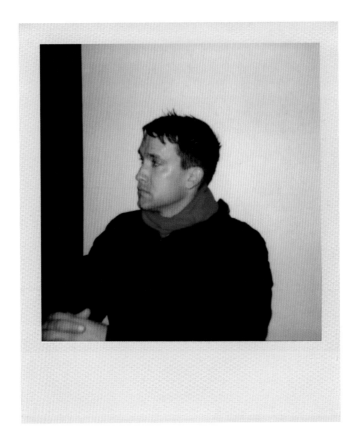

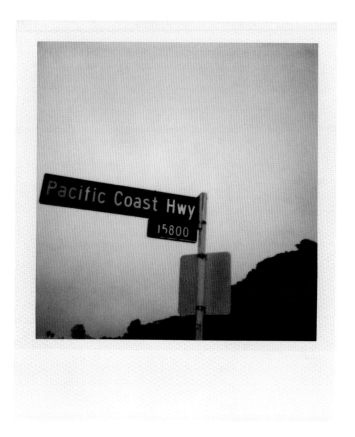

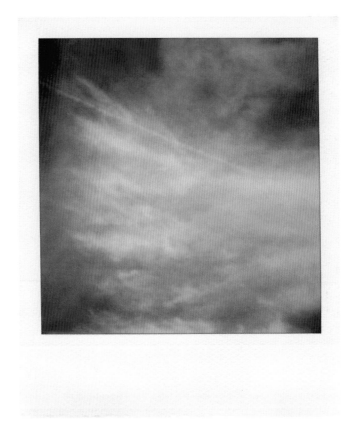

I USED TO TAKE PHOTOGRAPHS OF THE SKY AND MAIL THEM
TO PEOPLE. THEY WERE BASED ON THE IDEA OF A POSTCARD
– SHOWING A PLACE WHERE I AM AND THE OTHER IS NOT. BUT,
INSTEAD OF BEING WHERE I WAS, IT WOULD BE THE SKY FROM
WHERE I WAS - IT WOULD BE WHAT YOU SEE WHEN YOU LOOK
STRAIGHT UP. SOMETHING FASCINATING HAPPENS WHEN YOU
STARE STRAIGHT UP. LIKE LOOKING AT THE DARK, AN INFINITE
VOID COLLAPSES INTO A FLAT VISUAL SPACE. UNLIKE LOOKING
OUT AT SEA, WHERE THIS DISTANCE ENDS AT THE HORIZON,
THE SKY [AND THE DARK] JUST KEEPS GOING, BUT ALSO GOES
NOWHERE.

I AM THINKING ABOUT A DISTANCE. AND ALSO OF BOREDOM.

David Horvitz

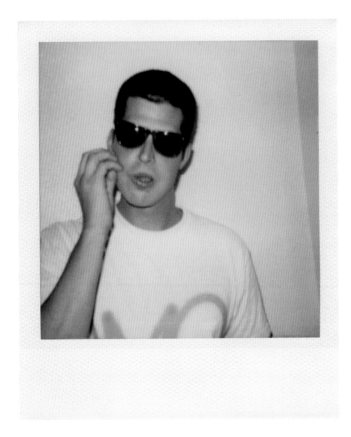

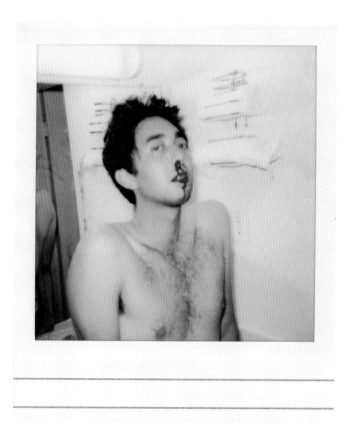

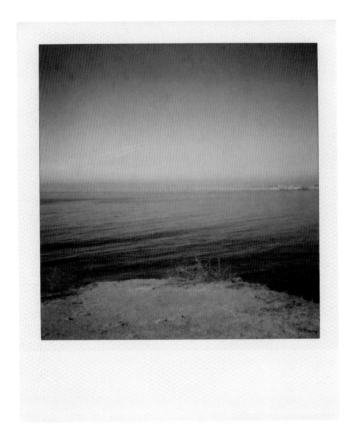

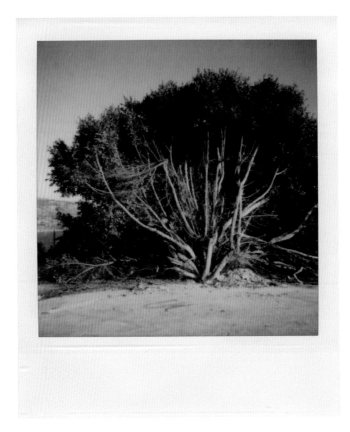

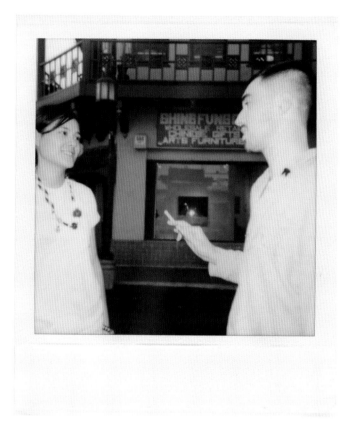

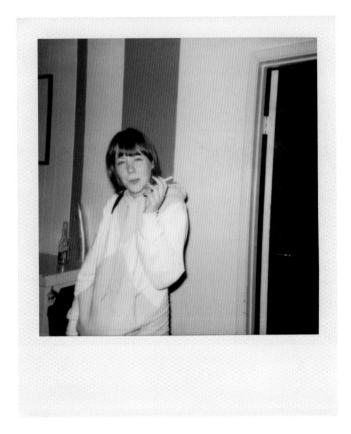

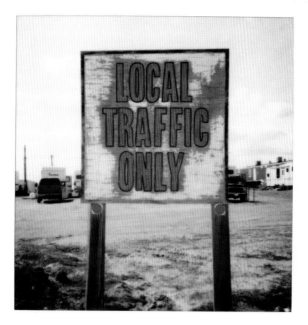

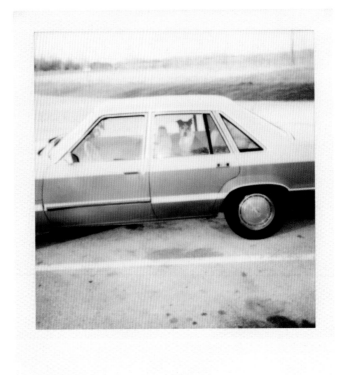

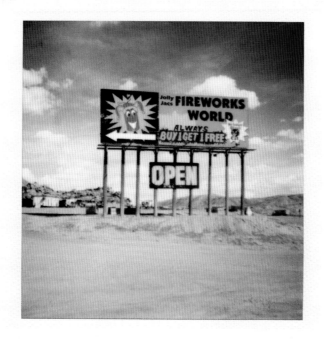

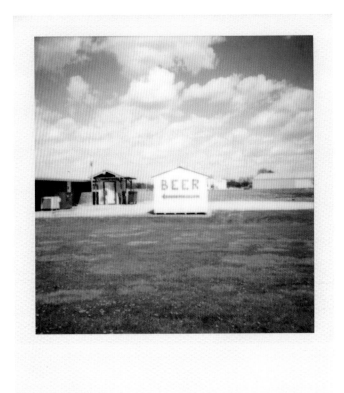

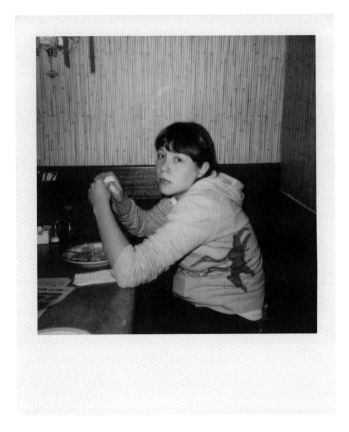

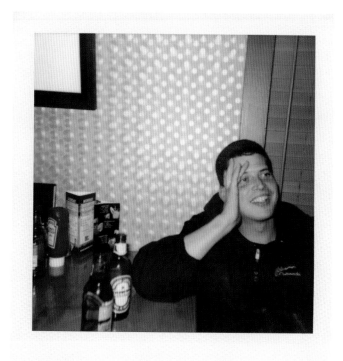

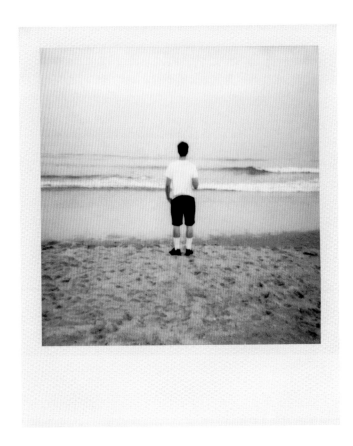

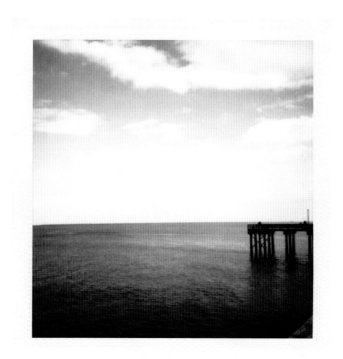

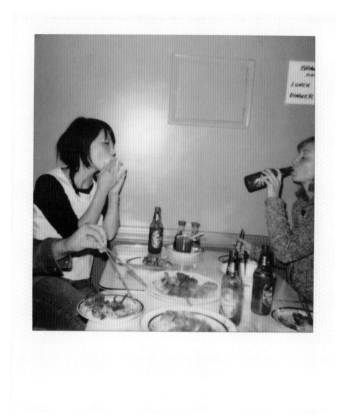

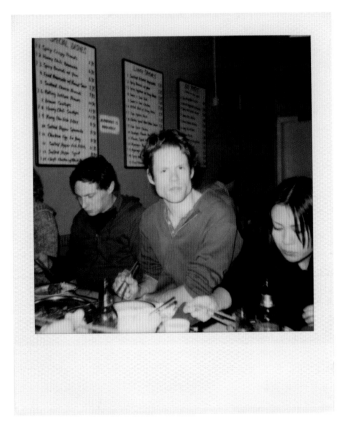

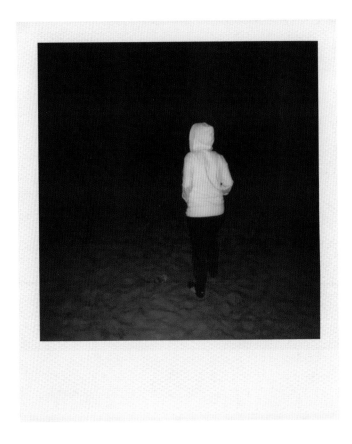

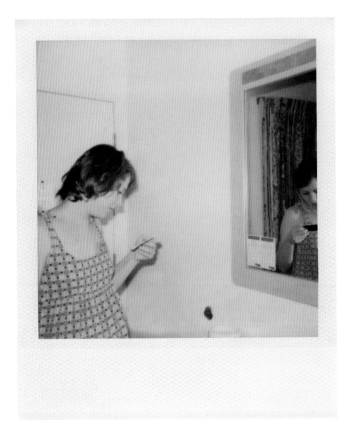

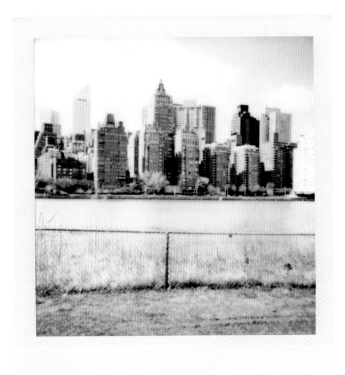

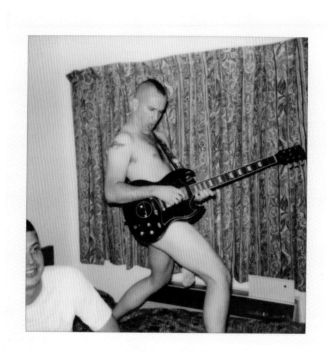

JAMIE STEWART RECEIVED THE FIRST EVER CASIOTONE FOR THE
PAINFULLY ALONE T-SHIRT WHEN I OPENED FOR THEM ON MY FIRST
EVER NATIONAL TOUR. IT WAS PINK AND JAMIE THREW UP ON IT
AND LEFT IT HANGING FROM A FENCE IN FRONT OF A HOUSE IN
ATLANTA.

Owen Ashworth, CASIOTONE FOR THE PAINFULLY ALONE

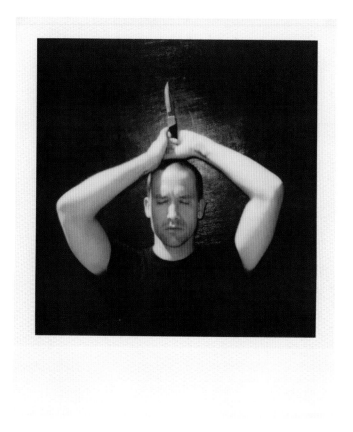

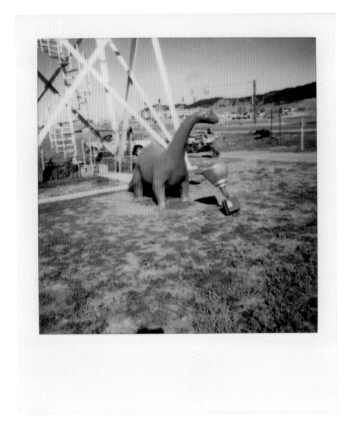

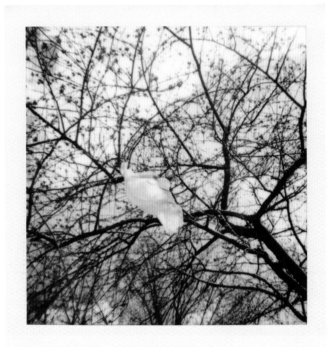

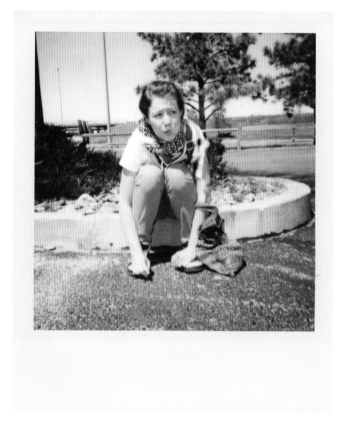

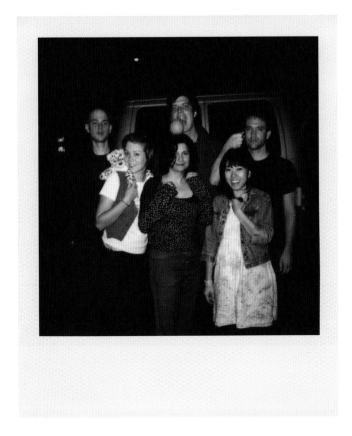

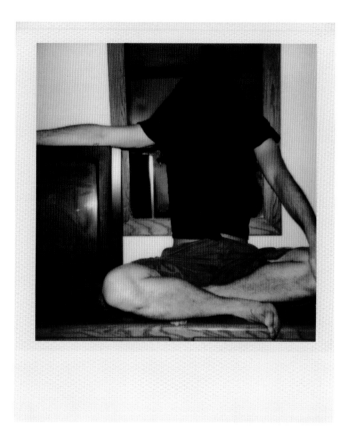

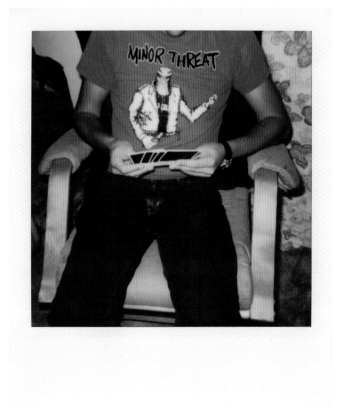

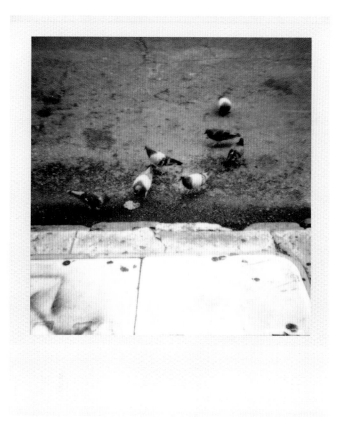

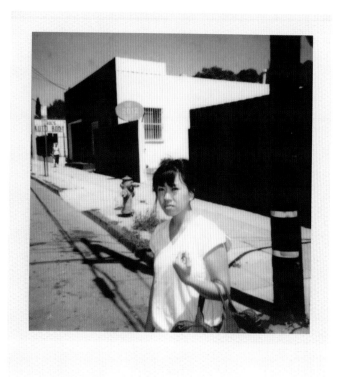

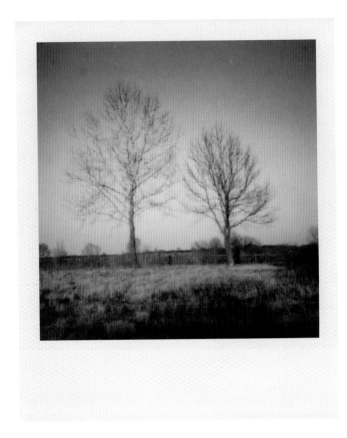

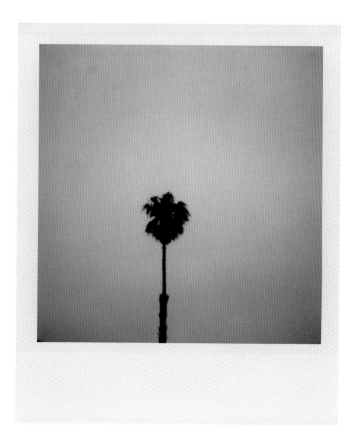

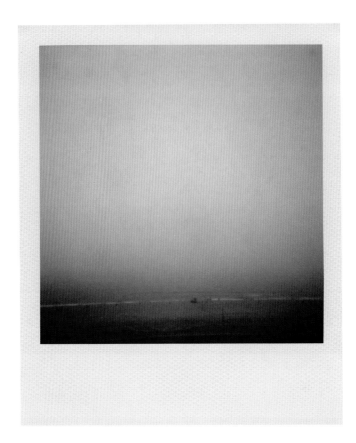

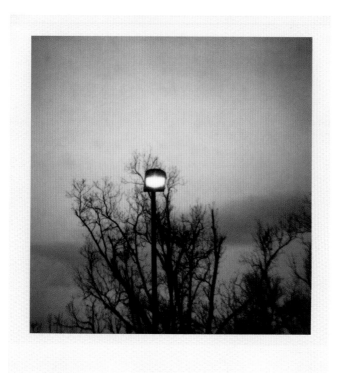

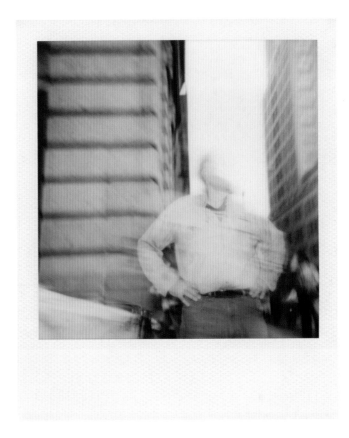

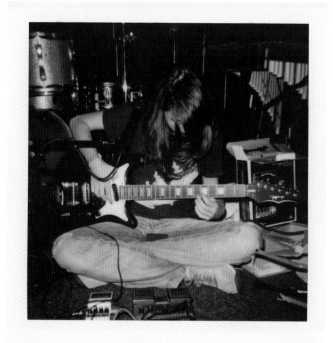

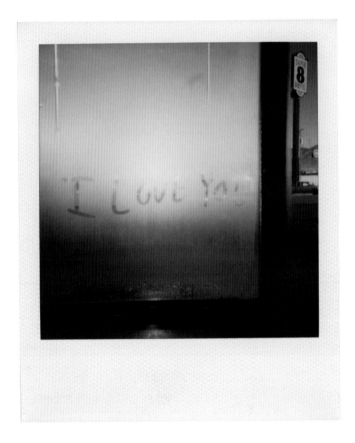

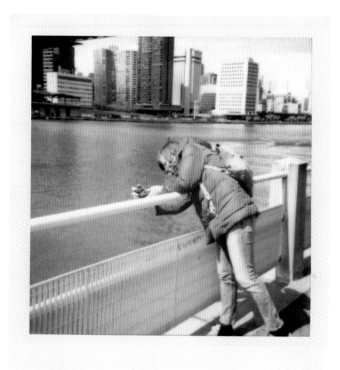

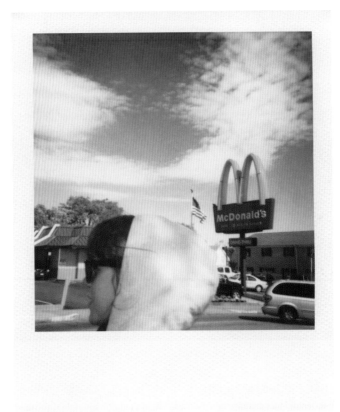

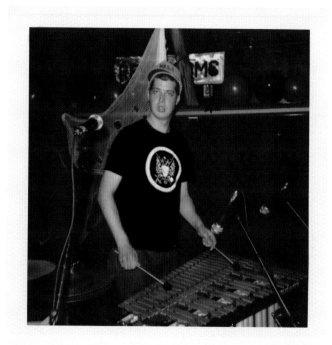

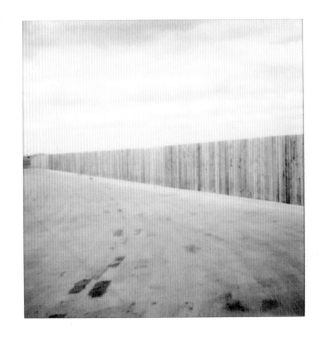

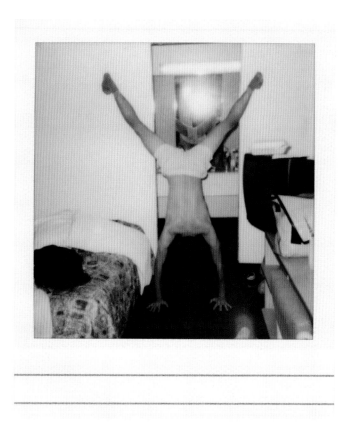

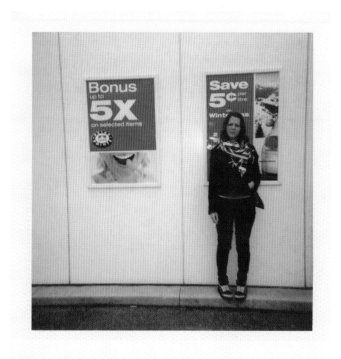

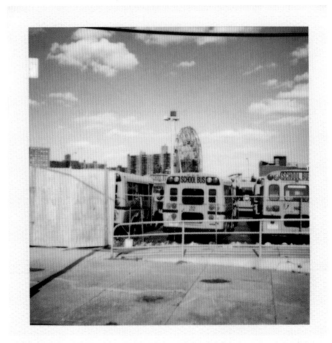

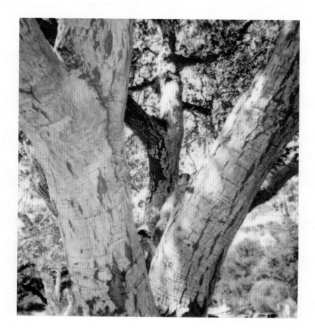

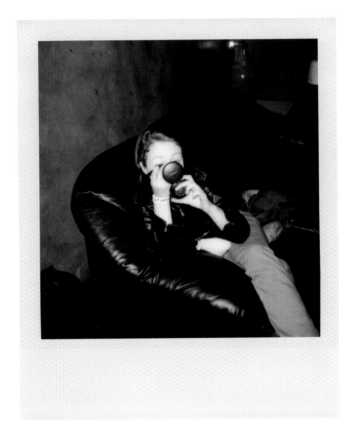

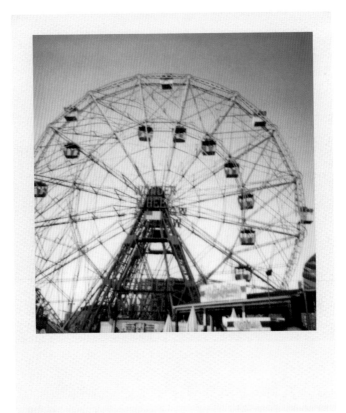

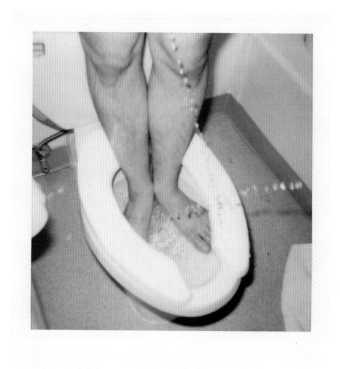

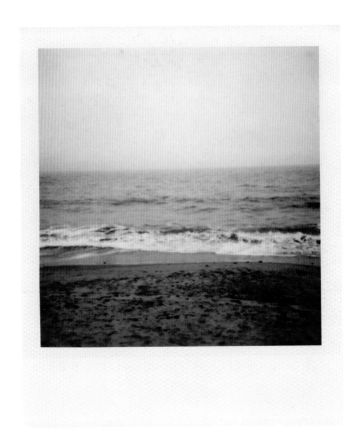

IN 'GET IN THE VAN' BY HENRY ROLLINS, HE MAKES TOURING LIFE OUT TO BE THE EQUIVALENT OF BEING DRAFTED INTO THE VIETNAM WAR. HE'S WRONG, IT'S WORSE. HORRIBLE 16-HOUR DRIVES, DAMAGING THE EARS OF A SMALL APPRECIATIVE CROWD OF 5 IN A HORRIBLE HIPPIE-RUN VENUE IN TEXAS, SHITTING YOUR PANTS IN YOUR SLEEP FROM FOOD POISONING, AND MAYBE MAKING $20 A NIGHT. IT'S MORE THAN ENOUGH TO GIVE ANYONE FLASHBACKS. WHEN JAMIE ASKED ME TO OPEN UP FOR XIU XIU ON A TOUR ACROSS CANADA IN THE SUMMER OF 2005, IT ALL CHANGED.

TO MY DELIGHT, I GOT TO PISS OFF A CRAZY SOUND GUY EVERY NIGHT, AND DAMAGE THE EARS OF MAYBE 100 UNAPPRECIATIVE KIDS, ALL WHILE HAVING FUN AND GETTING PAID FOR ONCE. DAVID HORVITZ CAME ALONG WITH ME AS MY ROADIE AND MERCH GUY. THE ONE THING ABOUT TOURING IN CANADA THOUGH IS THAT IT IS EXTREMELY DANGEROUS BECAUSE OF THE DRIVES, WHICH ARE COMPLETELY INSANE.

SOMETIMES WE WOULD DRIVE 10 HOURS, PLAY A SHOW, THEN HAVE TO GET BACK IN THE CAR AND DRIVE TILL 6:00 A.M. BECAUSE THE NEXT SHOW WOULD BE SO FAR AWAY. TO MAKE MATTERS WORSE, WHILE YOU ARE DRIVING AT 2:00 A.M. IN THE PITCH-BLACK NIGHT, THERE ARE TONS OF MOOSE JUST HANGING OUT ON THE SIDE OF THE HIGHWAY JUST WAITING TO RUN OUT INTO THE ROAD IN FRONT OF YOUR VEHICLE. IF YOU HIT ONE OF THOSE BIG SMELLY SUCKERS YOU ARE DEAD. CANADA ALSO HAS ALL THESE SIGNS POSTED UP ON THE SIDE OF THE ROAD JUST TO WARN AND REMIND YOU THAT THEY ARE OUT THERE, THESE LOOSE MOOSE. THE SIGNS SHOW A DERANGED MOOSE WHO HAS FUCKING LASER BEAMS FOR EYES STEPPING OUT ONTO THE HIGHWAY AND RIGHT BELOW THE BEAST THE SIGN READS: MOOSE ON THE LOOSE.

Freddy Ruppert, THIS SONG IS A MESS BUT SO AM I

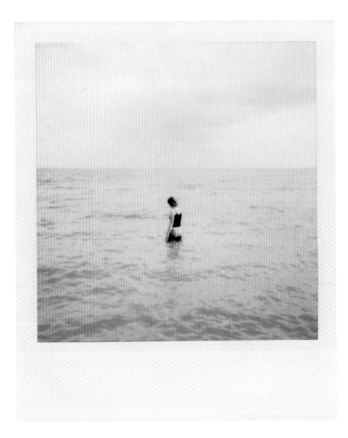

IN SOME WAY THESE PICS WERE THE XIU XIU WE KNEW AND LOVED: FEARLESS, CREATIVE, DEPRESSED, FUNNY, SELF-DEPRECATING, OVERLY HONEST. BUT LOOKING THEM OVER EACH TIME SOME MORE CROPPED UP ON THE INTERNET, THEY REALLY DIDN'T HELP ME FEEL LIKE I KNEW THE BAND BETTER. I THINK I'M MORE CONFUSED NOW THAN BEFORE, ACTUALLY. THE MORE PICS I SAW, THE LESS I UNDERSTOOD ABOUT XIU XIU. IT WASN'T LIKE A TOUR DIARY OR A "REALITY" VIDEO, SINCE THEY DON'T ADD UP TO ANYTHING, NO STORY, NO PAYOFF. ALSO IT WAS IMPOSSIBLE TO TELL WHICH WERE POSED AND WHICH WERE "REAL." OF COURSE, THAT'S THE WHOLE GIST OF CONTEMPORARY SELF-PROMOTION. BUT SOME OF THESE PICS WERE SO MUNDANE OR REPELLANT THAT I HAD TO WONDER IF THEY WERE REALLY PROMOTION AT ALL. MORE LIKE A WAY OF TWISTING THE MAINSTREAM BACK ON ITSELF, TURNING THE CRASS AND UGLY INTO ART, LIKE XIU XIU'S LYRICS, AN ATTEMPT AT GRAPPLING WITH THE DARK SIDE, "OWNING YOUR OWN SHADOW."

Greg, DEERHOOF

A SOUNDTRACK FOR A POLAROID OF TWO TREES IN INDIANA

MASTERED BY JHEREK BISCHOFF

FIELD RECORDINGS COLLECTED BY DAVID HORVITZ
ON NORTH AMERICAN XIU XIU TOURS IN 2006 AND 2007.

01 • DORIS IMPROV III [XIU XIU] • 4:18

02 • BLUE DICKS [AZ] • 0:19

03 • DRIVING CANADA 3AM MOOSE ON THE LOOSE [THIS SONG IS A MESS BUT SO AM I] • 3:46

04 • LILAC [MI] • 0:43

05 • DAVID AND THE WOLF [PARENTHETICAL GIRLS] • 1:38

06 • BEECH DROPS [FL] • 1:40

07 • B SIDE IS SILENT [BARR] • 4:20

08 • FAIRY DUSTER [AZ] • 0:44

09 • BOG ROSE [NC] • 0:13

10 • SECOND WIND / ZOMBIE SKIN [GROUPER] • 4:17

11 • GOLDENROD [SC] • 1:01

12 • SALAM HALE SHOMA / FERROCARIL • 0:36

13 • FOLK SONG [CHES SMITH OF XIU XIU] • 1:07

14 • SHEPHERD'S PURSE [KY] • 1:44

15 • SPIDERWORT [FL] 0:17

16 • GREEN TEA AT DENNY'S [MARY PEARSON OF HIGH PLACES] • 1:28

17 • BEARD TONGUE [WA] • 1:04

18 • IMOC [JHERKEK BISCHOFF OF THE DEAD SCIENCE] • 4:12

19 • THE MENTORS GO TO SCHOOL • 2:28

20 • INSTRUMENTAL [CASIOTONE FOR THE PAINFULLY ALONE] • 3:43

21 • BRING IT ALL BACK HOME [THE YELLOW SWANS] • 11:16

22 • CAT'S EAR [OR] • 1:41